SEEING **The Getty Collections**

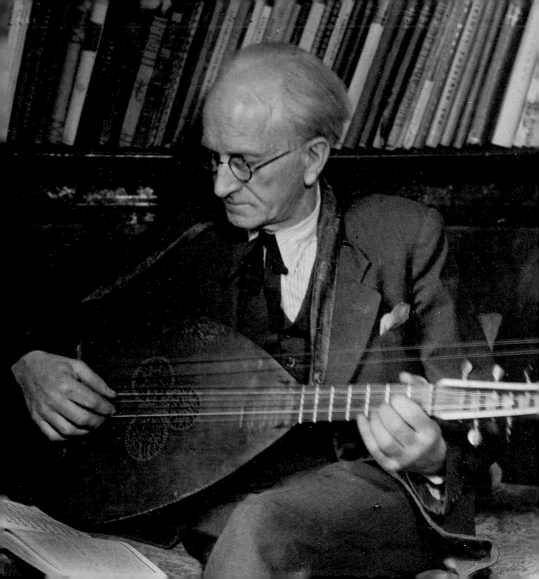

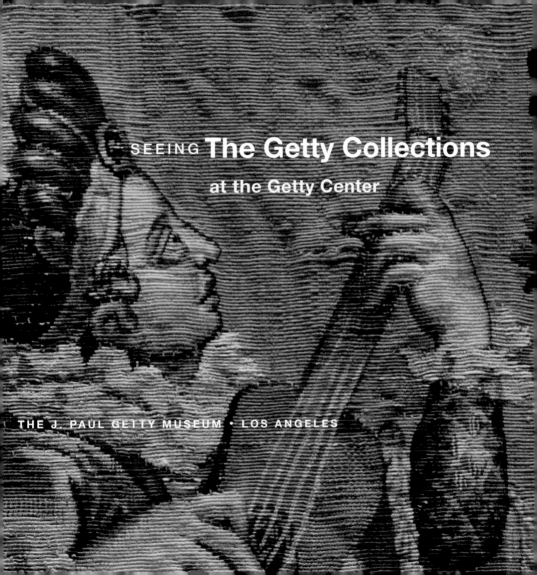

SEEING **The Getty Collections**
at the Getty Center

THE J. PAUL GETTY MUSEUM • LOS ANGELES

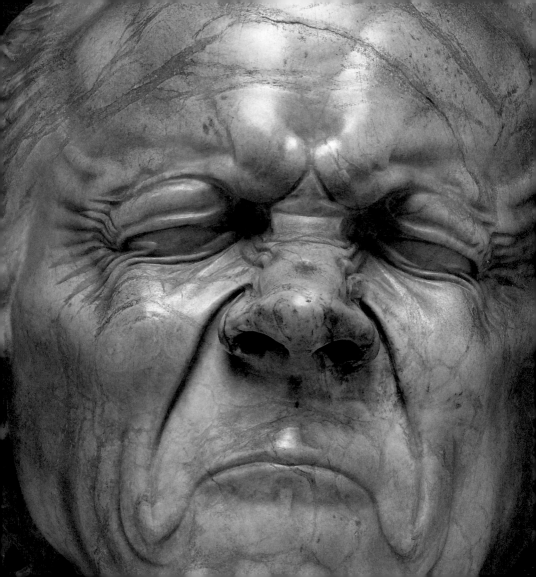

FOREWORD

The experience of touring a museum is unique to every visitor. Each of us comes with our own expectations, memories, knowledge, tastes. Some of us come for a very focused purpose—to see a particular work we are professionally interested in or to see a special exhibition we have heard about and found intriguing—and some of us come simply to spend an hour or two in old, familiar galleries among works we have known for years or to wander amid a collection entirely new to us. And when we leave, we take our own particular impressions with us—memories of works, or even simply parts of works, that struck us as beautiful or odd or mysterious.

In this small book, we have tried to recreate the experience of visiting a museum, and the surprise and delight of discovering similarities among otherwise disparate works. In trying to capture what any of us might take away from a casual stroll through our collections, we have chosen to show portions of works that bear coincidental or perhaps purposeful relationships—in style or subject—to other works pictured next to them. Although we think the works chosen for this book are very fine indeed, we are not singling them out as "highlights." We simply chose those that caught the trained and eager eyes of our photographic staff or of the designer of this volume, Kurt Hauser, and that led them to see connections among the works that, in many cases, they themselves were noticing for the first time. All the works are described on the last pages of the book.

We hope you will enjoy leafing through this "virtual tour;" we hope that you will see a few works that are familiar to you and others that you would like to examine more closely. Most of all, we hope that this book entices you to visit the Getty, again and again.

David Bomford
Associate Director of Collections
The J. Paul Getty Museum

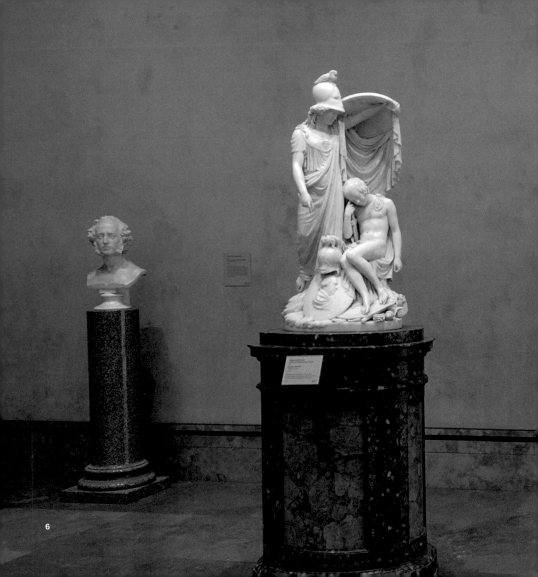

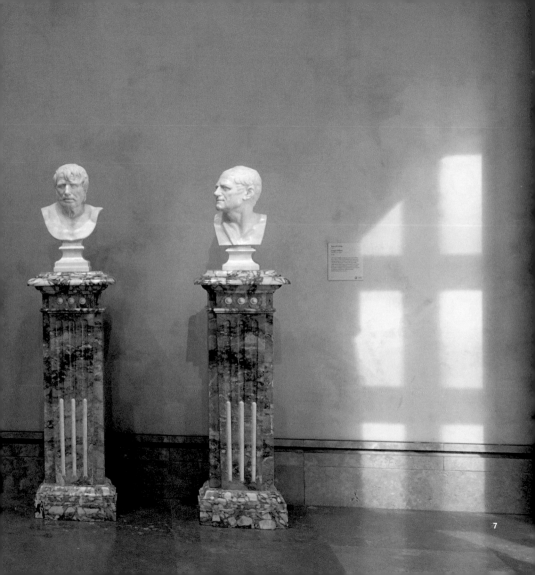

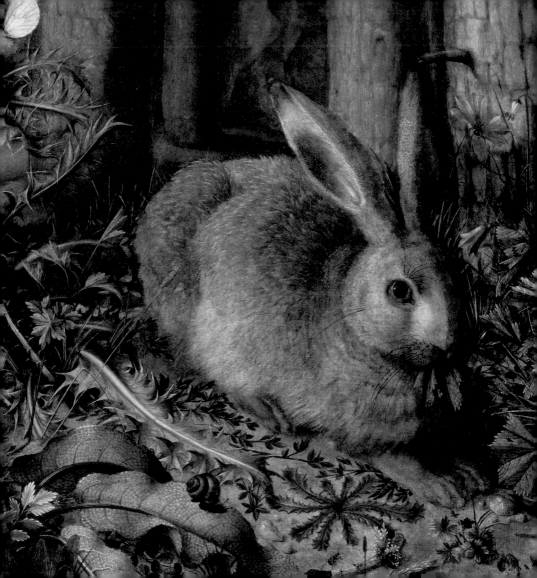

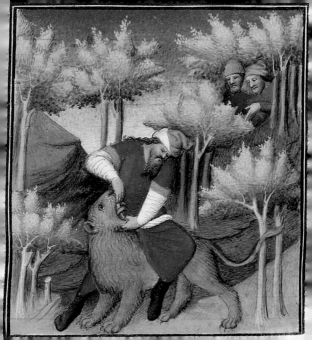

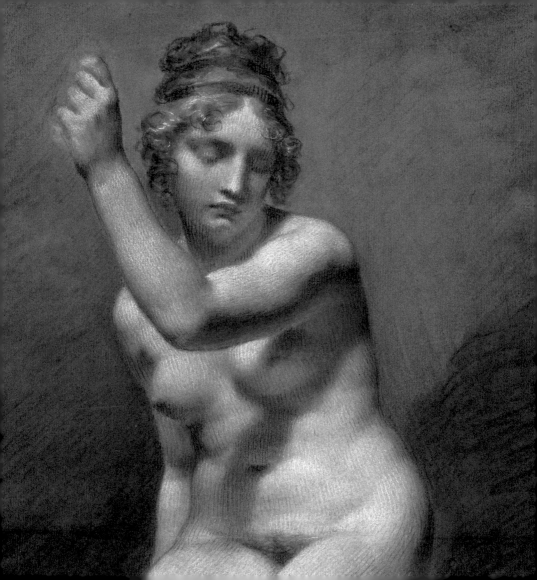

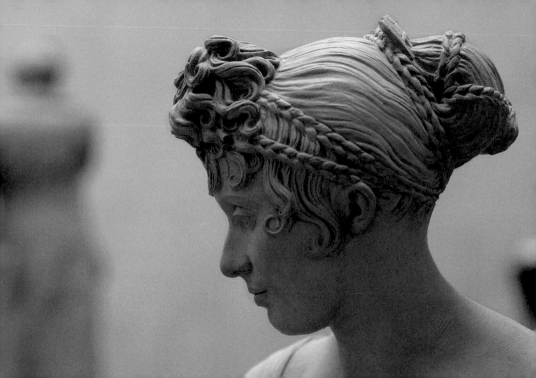

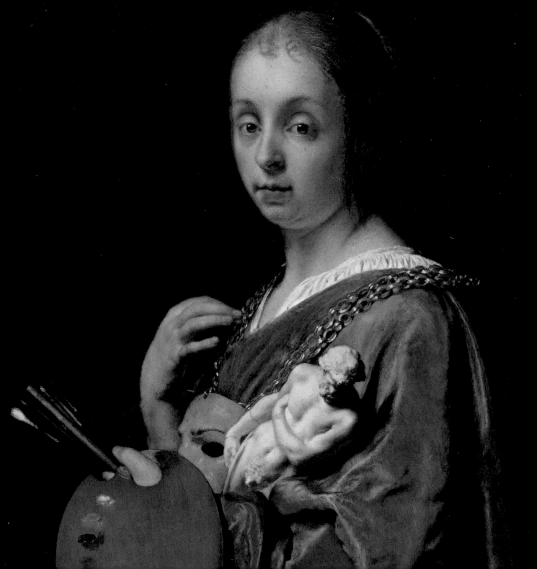

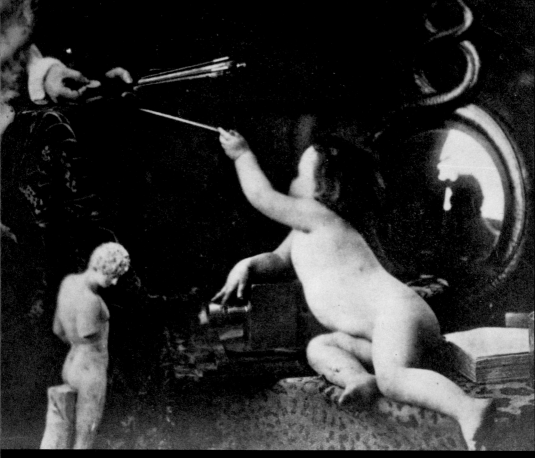

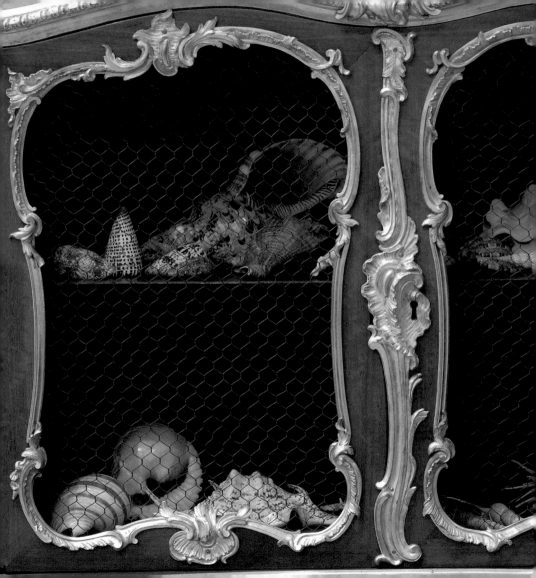

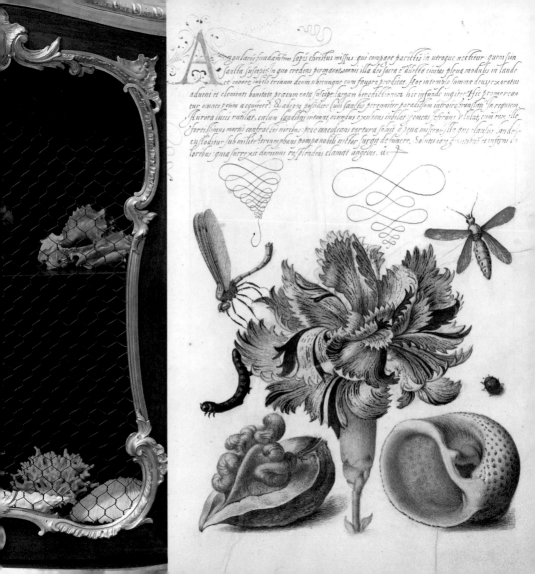

Angularis fundamentum lapis christus missus: qui compage parietis in utroque netitur: quem sion
sancta suscepit: In quo credens permanet omnis: illa deo sacra & dilecta ciuitas plena modulis in laude
et canore, in illo trinum deum ubicunque cum fauore prodiat. Hoc intento lumine deus exoratus
adueni et elementis bonitate precatum uota suscipe: largam benedictionem hic infunde iugiter. Hic promerean-
tur omnes petita a equirere? Ad ipsa possidere cum sanctis perenniter paradisum introire translati. In regnum
Aurora lucis rutilat, celum laudibus intonat, mundus exultans iubilat gemens ferinus Vlulat, cum rex ille
fortissimus mortis confra ctis viribus: pede conculcans tartara soluit a pena miseros: Ille qui caulus laudem
custoditur sub milite & triumphani pompa nobili victor surgit de funere. Soluti iam gaudentibus et inferni vi-
loribus: quia surrexit dominus resplendens clamat angelus. et

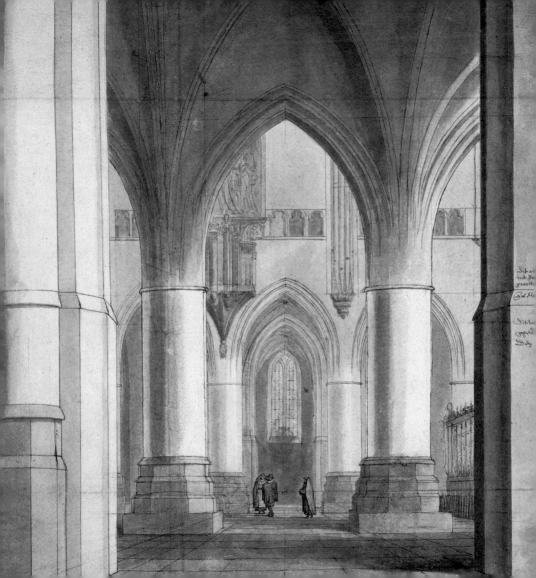

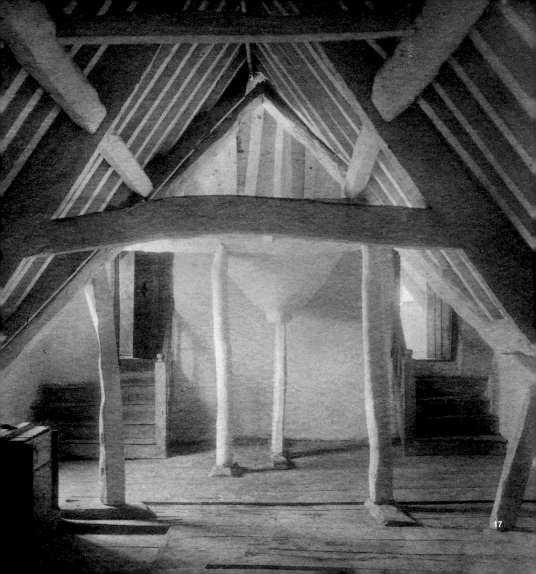

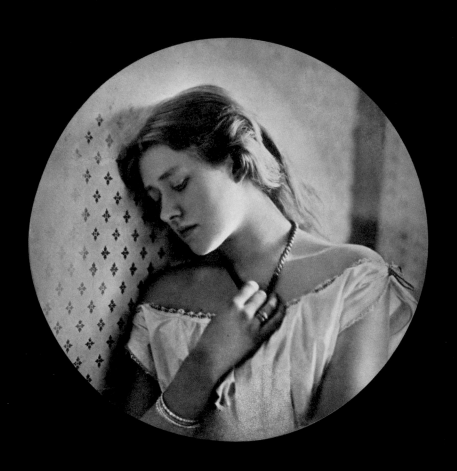

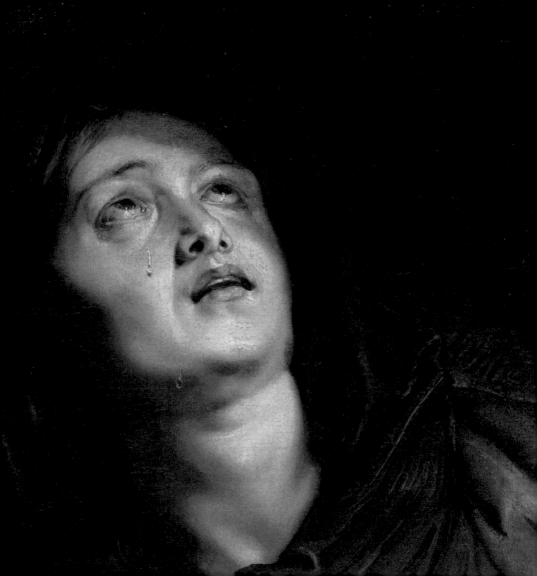

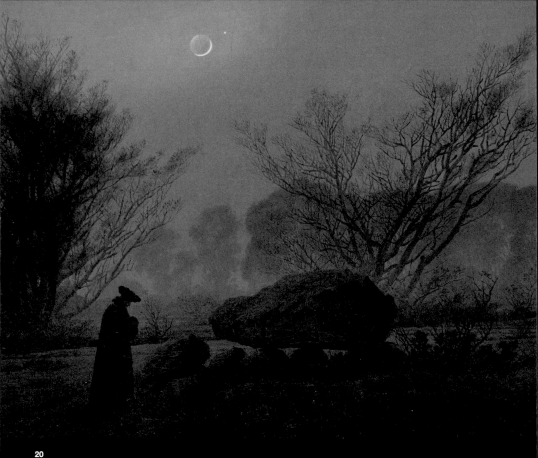

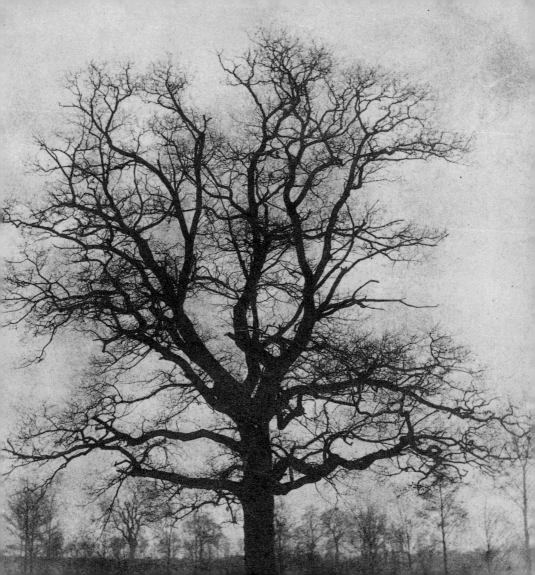

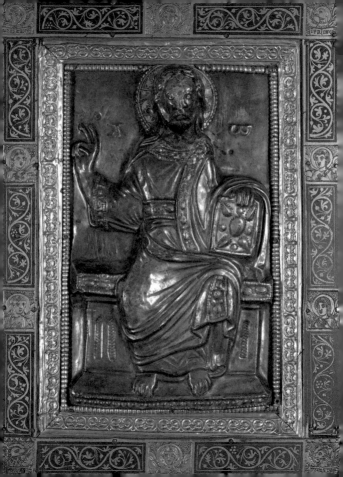

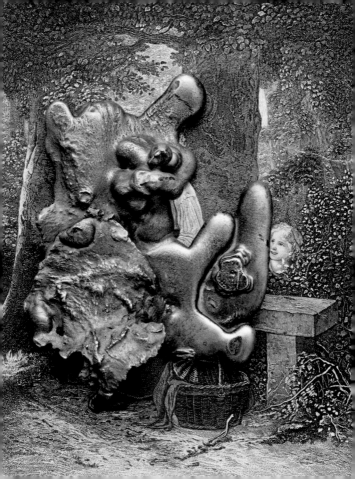

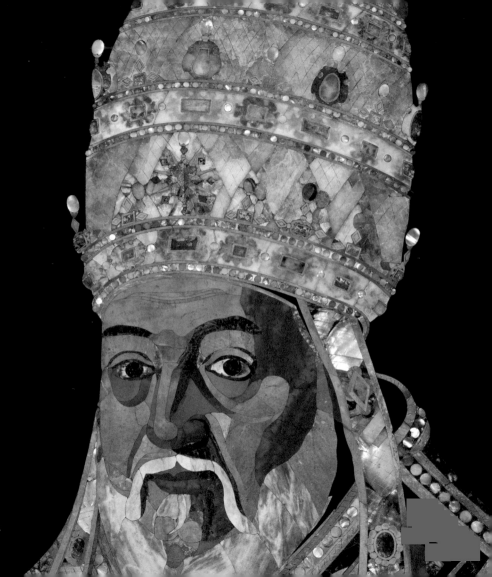

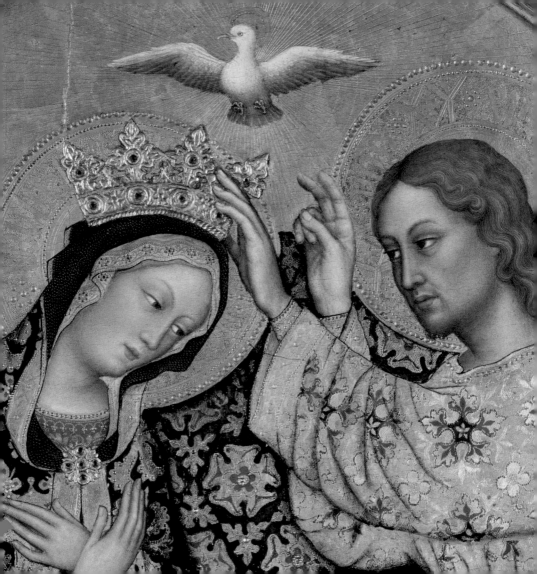

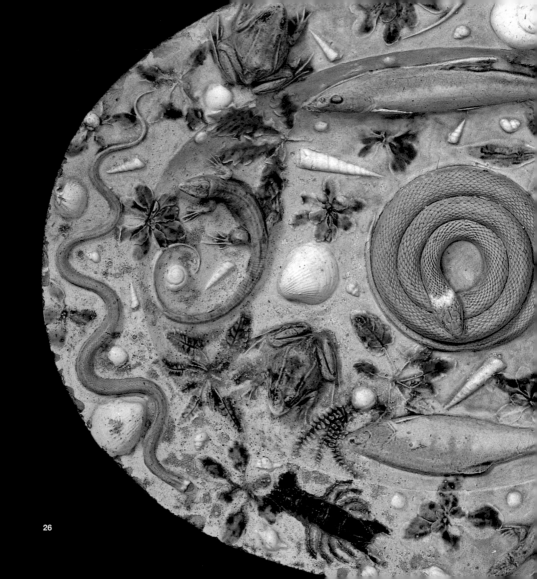

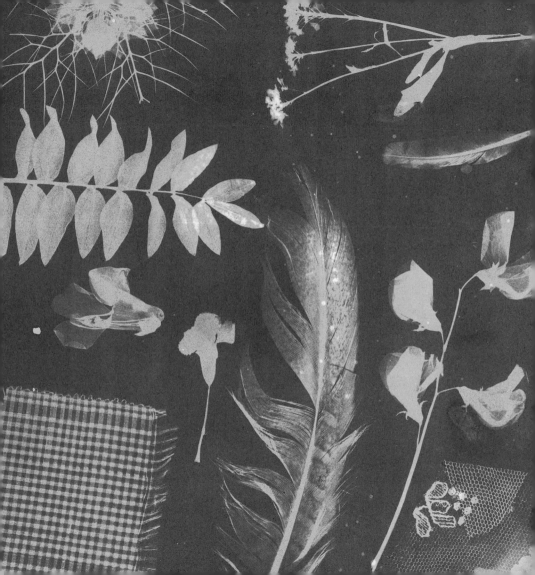

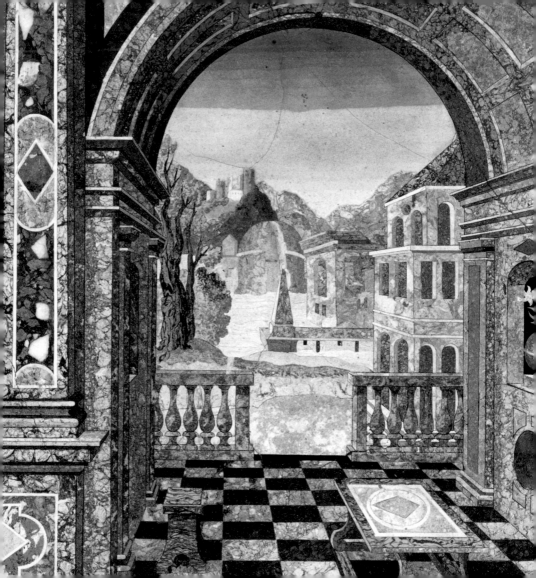

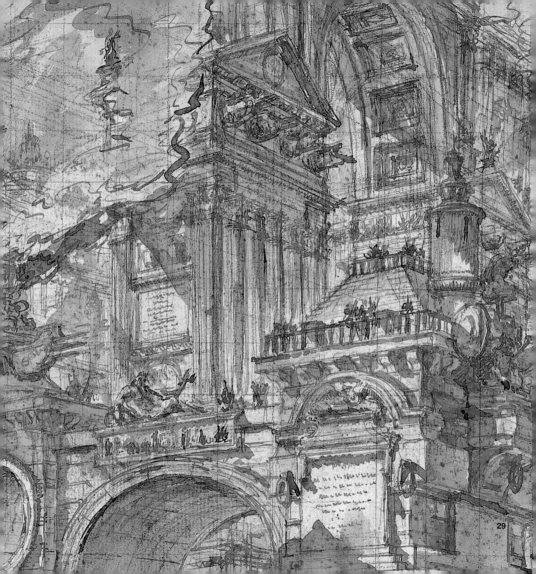

29

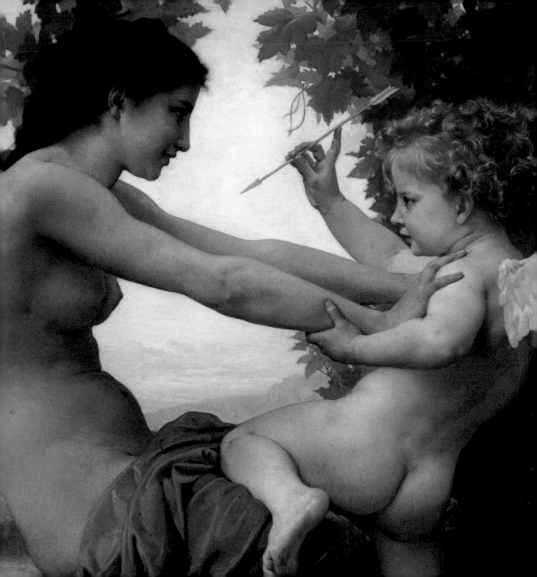

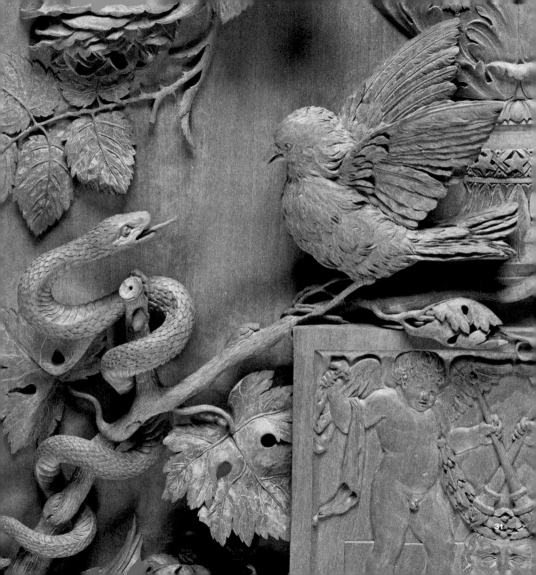

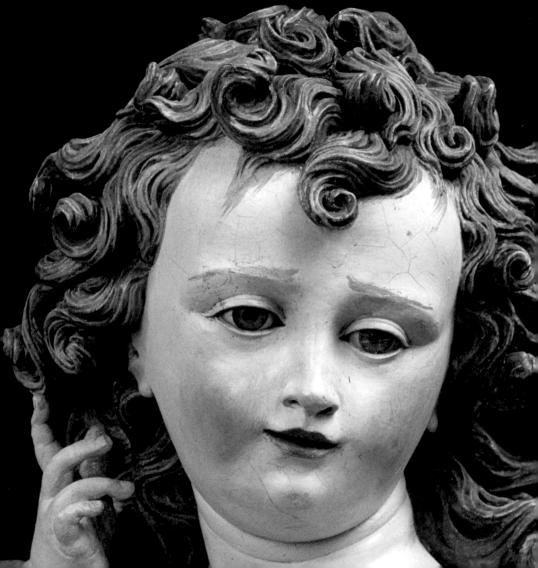

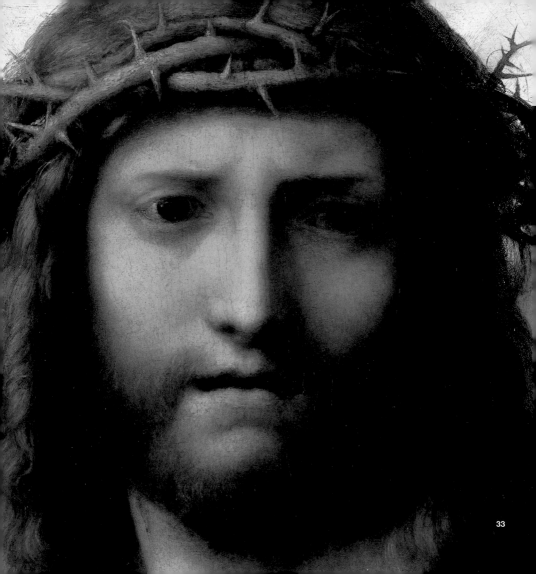

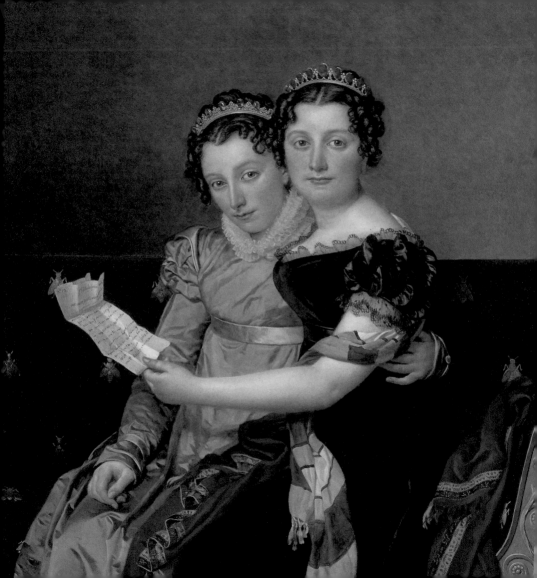

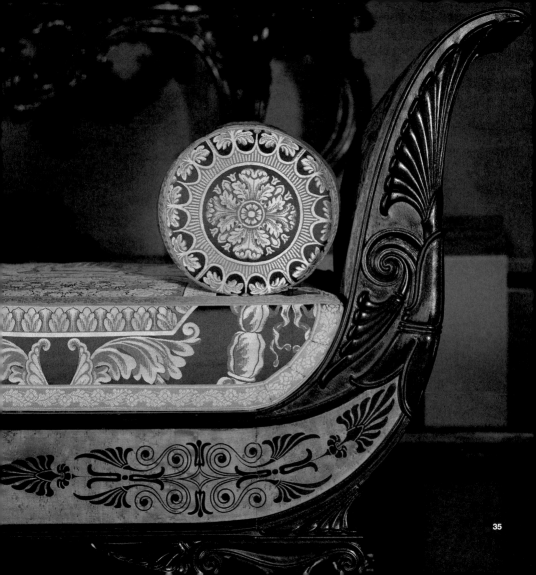

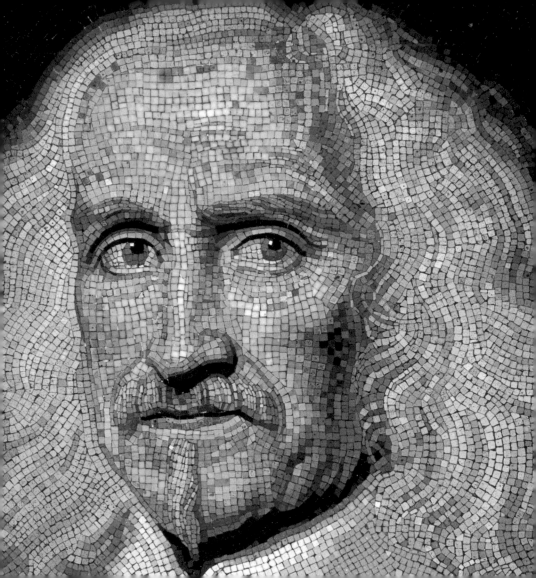

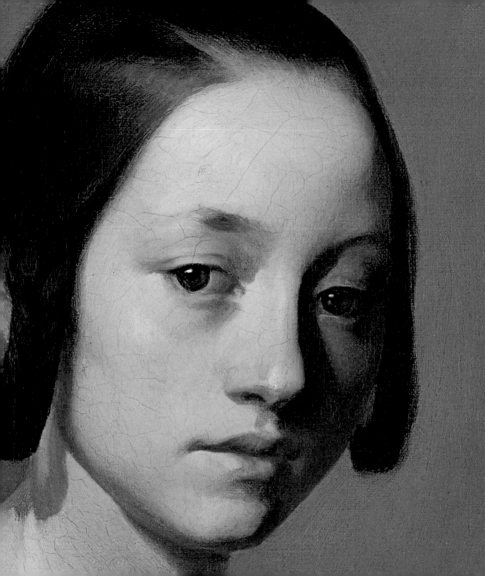

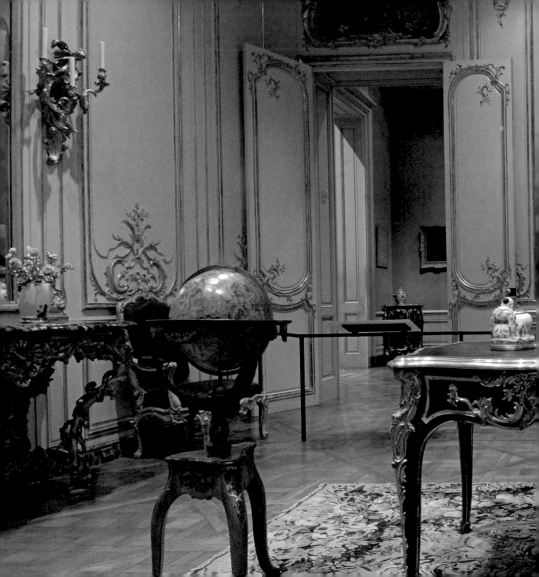

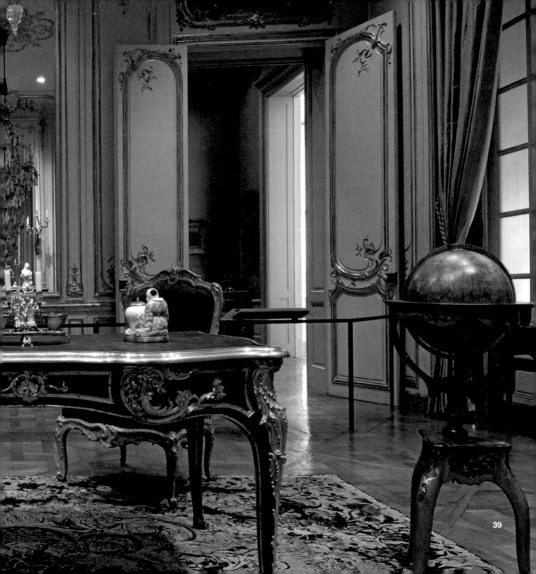

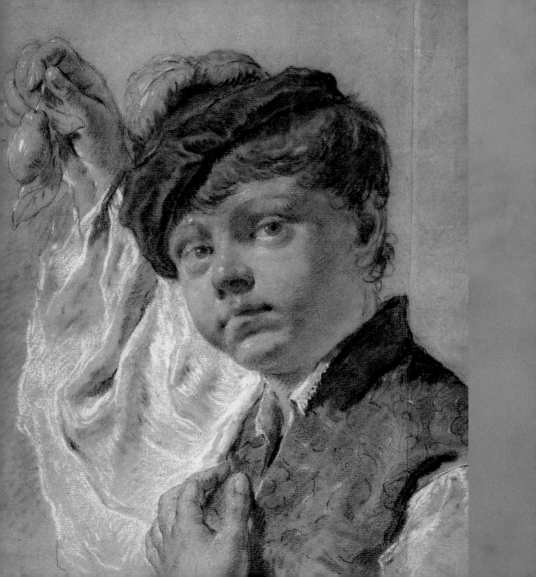

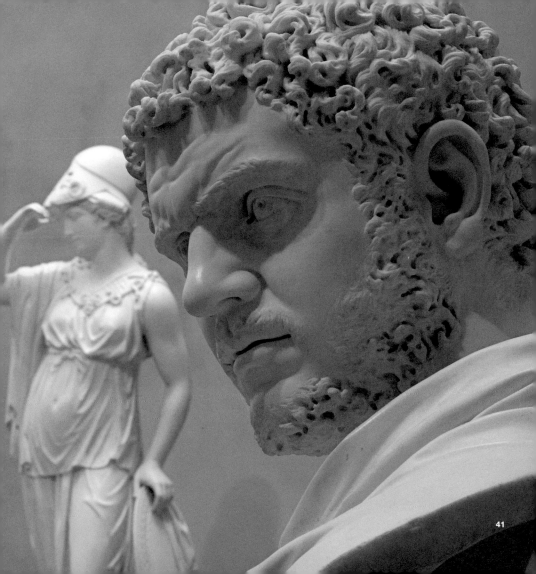

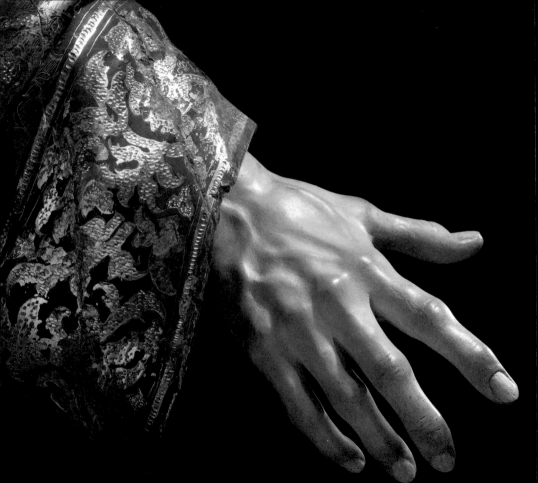

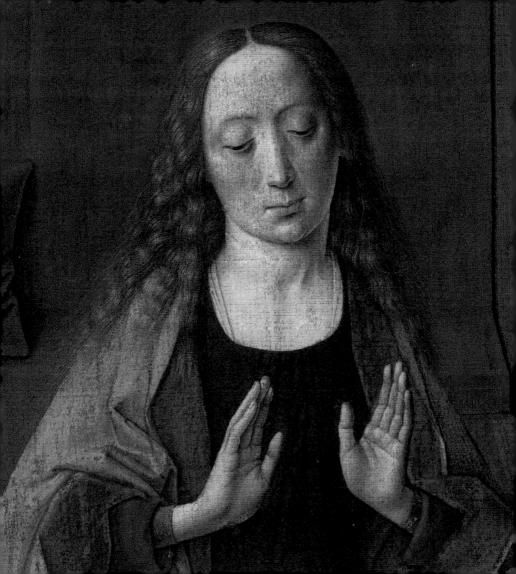

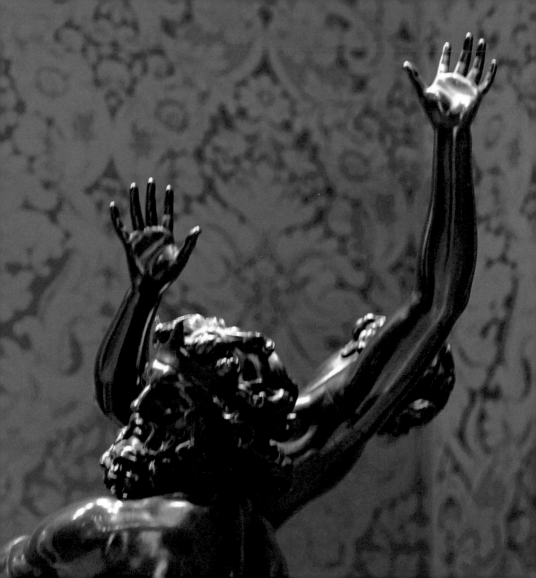

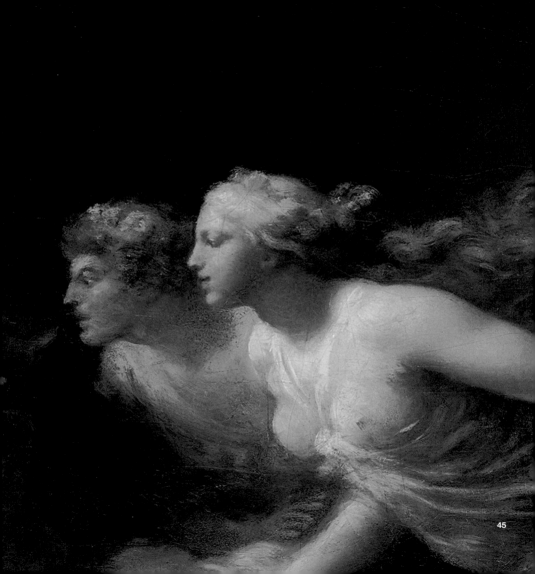

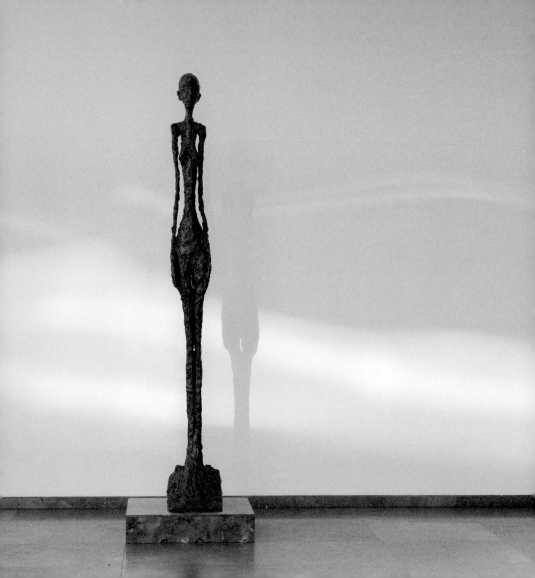

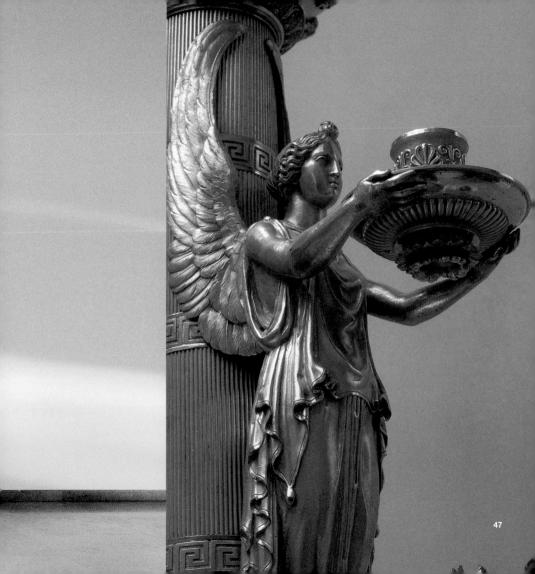

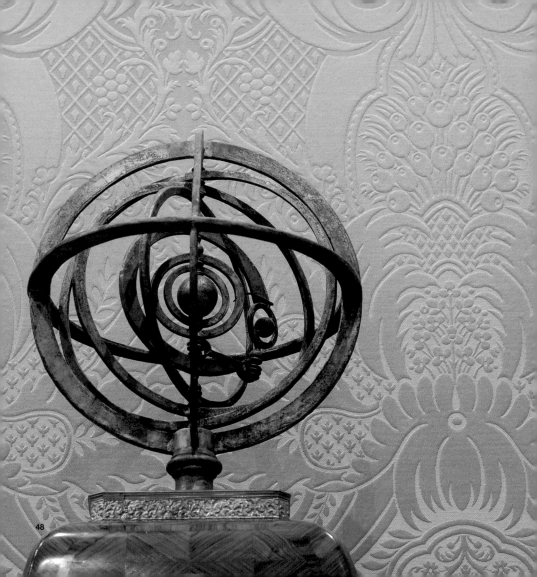

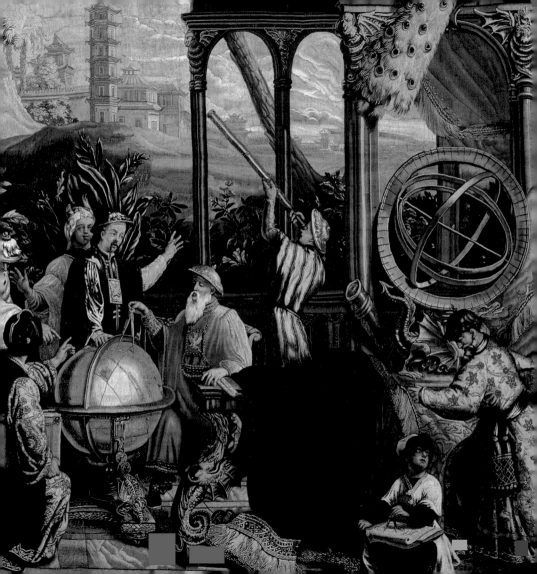

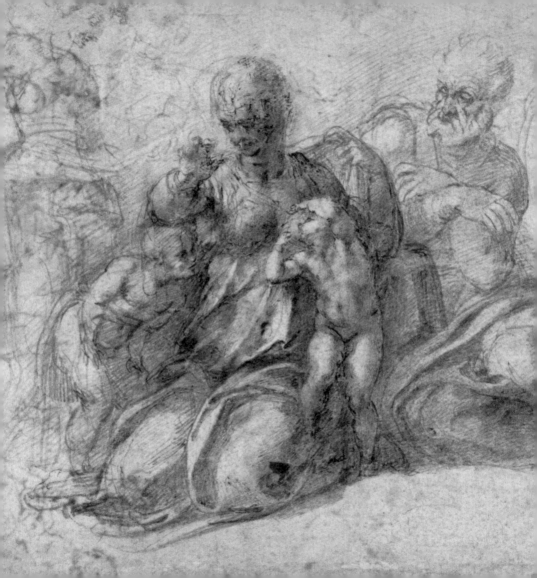

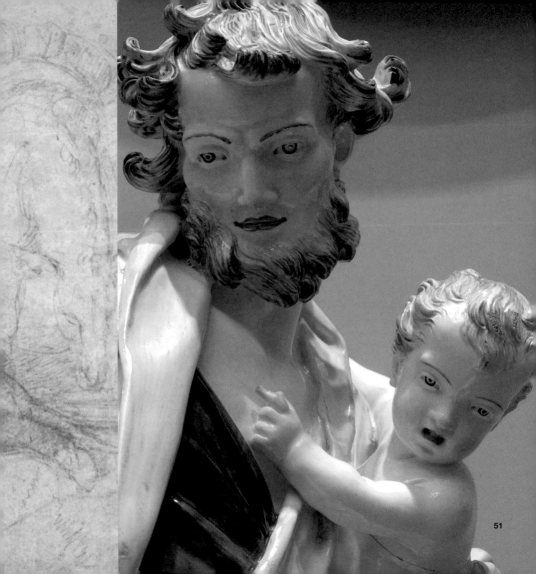

51

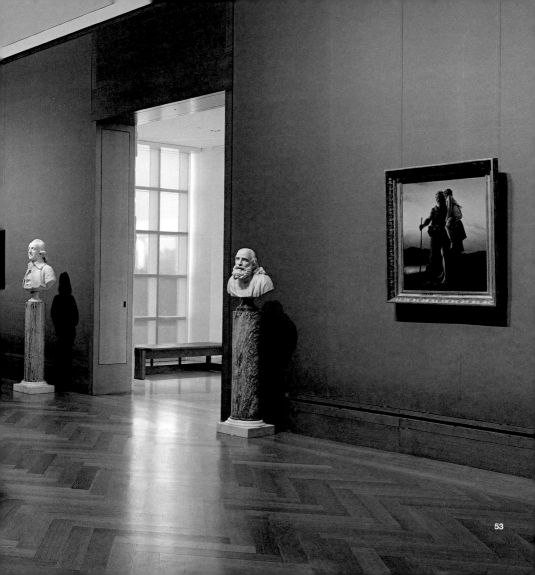

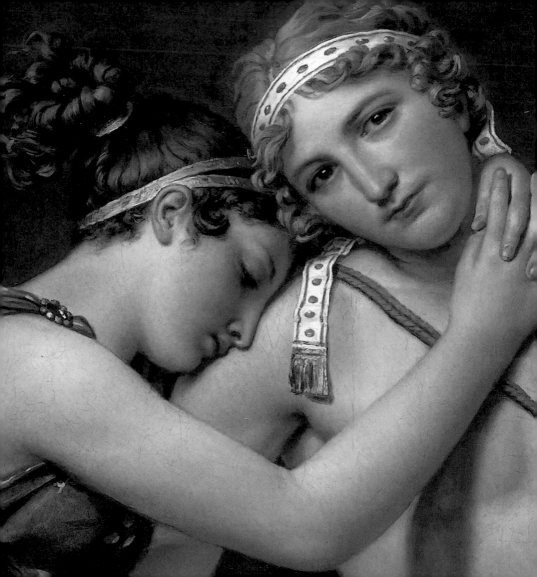

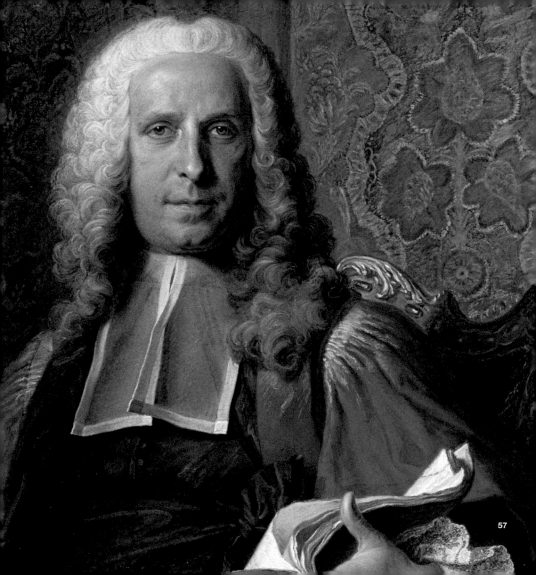

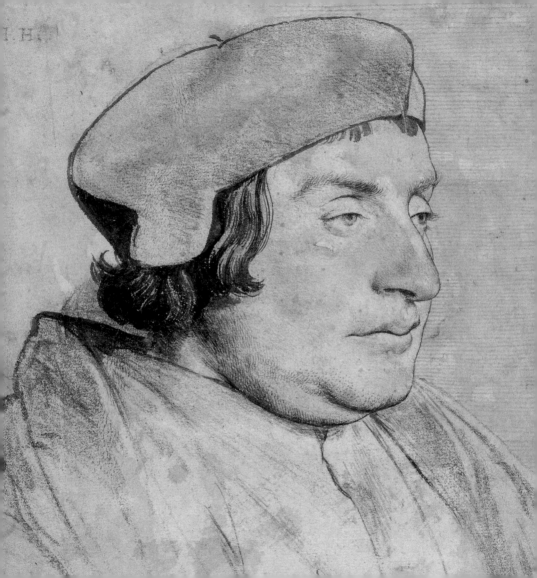

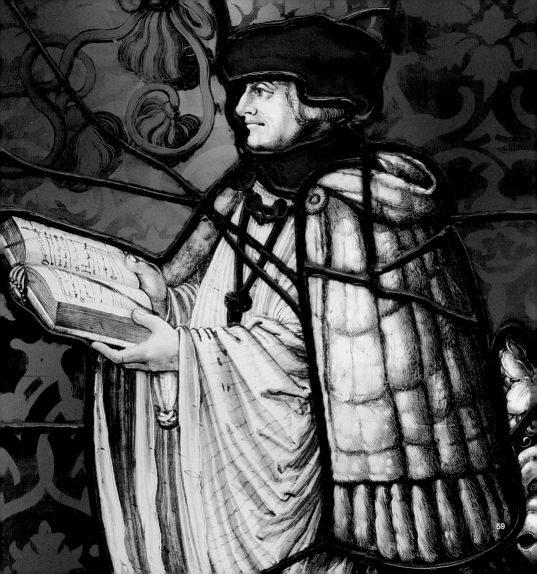

ILLUSTRATIONS

All images are details taken from the works of art listed below (numbers refer to pages). In most cases, the full work is illustrated, with commentary, in *The J. Paul Getty Museum: Handbook of the Collections* (7th edition, 2007)

Unless otherwise noted, all photographs were taken by the staff of the Imaging Services Department of the J. Paul Getty Museum and are © J. Paul Getty Trust

Front cover
Francisco de los Cobos y Molina,
ca. 1530–32
JAN GOSSAERT (*called* Mabuse)
Netherlandish, ca. 1478–1532
Oil on panel
43.8 × 33.7 cm (17¼ × 13¼ in.)
88.PB.43

Front flap
Medusa, 1911
VINCENZO GEMITO
Italian, 1852–1929
Parcel-gilt silver
H: 23.5 cm (9¼ in.)
86.SE.528

Back cover
Long-case Musical Clock, ca. 1712
Attributed to
ALEXANDRE-JEAN OPPENORDT
French, 1639–1715
Veneered with brass and tortoise
shell on oak carcass; bronze mounts,
enameled metal
266.7 × 104.1 × 39.4 cm
(8 ft. 9 in. × 3 ft. 5 in. × 1 ft. 3¼ in.)
72.DB.40
[Detail of bronze mount]
Photo: Richard Ross

1 *The Portal of Rouen Cathedral
in Morning Light*, 1894
CLAUDE MONET
French, 1840–1926
Oil on canvas
100 × 64.9 cm (39⅜ × 25⁹⁄₁₆ in.)
2001.33
Photo: Richard Ross

2 *Self-Portrait Playing the Lute*,
ca. 1940–44
AUGUST SANDER
German, 1876–1964
Gelatin silver print
22.5 × 16.8 cm (8⅞ × 6⅝ in.)
84.XM.126.68

3 Tapestry depicting musicians
and dancers, 1690–1730
Beauvais Manufactory
French, founded in 1664
After designs by JEAN-BAPTISTE
MONNOYER, 1636–1699
Wool and silk
316.87 × 521.97 cm
(10 ft. 4¾ in. × 17 ft. 1½ in.)
2003.4
Photo: Richard Ross

4 *The Vexed Man*, after 1770
FRANZ XAVER MESSERSCHMIDT
German, 1736–1783
Alabaster
2008.4

6-7 GALLERY OF EUROPEAN SCULPTURE
FROM 1750 TO 1850
Photo: Richard Ross

from left to right:

6a *Bust of Felix Mendelssohn*, 1848
ERNST FRIEDRICH
AUGUST RIETSCHEL
German, 1804–61
Marble
59.7 cm (23½ in.)
86.SA.543

6b *Allegorical Portrait of the
van Risamburgh Family*, 1790
JOSEPH CHINARD
French, 1756–1813
Marble
H: 112.4 cm (44¼ in.)
94.SA.2

7a *Bust of Pseudo-Seneca*
(after the antique), 1755–65
JOSEPH WILTON
British, 1722–1803
Marble
H: 61 cm (24 in.)
87.SA.111

7b *Bust of a Man* (after the antique), 1758
JOSEPH WILTON
British, 1722–1803
Marble
H: 59.7 cm (23½ in.)
87.SA.110

8 *A Hare in the Forest*, ca. 1585
HANS HOFFMANN
German, ca. 1530–1591/92
Oil on panel
62.2 × 78.4 cm (24½ × 30⅞ in.)
2001.12

9 *Des cas des nobles hommes et femmes*
GIOVANNI BOCCACCIO
Italian, 1313–75
Parchment, 318 leaves
42 × 29.6 cm (16⁹/₁₆ × 11⅝ in.)
Illustration: *Samson and the Lion*
(fol. 26v) by the Boucicaut Master
and Workshop, ca. 1415
Ms. 63; 96.MR.17

10 *Study of a Female Nude*, ca. 1800
PIERRE-PAUL PRUD'HON
French, 1758–1823
Black and white chalk with stumping, on
blue paper
60.4 × 31.8 cm (23¾ × 12½ in.)
99.GB.49

11 *The Family of General Philippe-Guillaume
Duhesme*, ca. 1808
JOSEPH CHINARD
French, 1756–1813
Terracotta
56 × 34.9 × 70 cm
(22¹/₁₆ × 13¾ × 27⁹/₁₆ in.)
85.SC.82
Photo: Richard Ross

12 *An Allegory of Painting*, 1661
FRANS VAN MIERIS THE ELDER
Dutch, 1635–1681
Oil on copper
12.5 × 8.5 cm (5 × 3½ in.)
82.PC.136

13 *The Infant Photography Giving the Painter
an Additional Brush*, ca. 1856
OSCAR GUSTAVE REJLANDER
British (b. Sweden), 1813–1875
Albumen print
6 × 7.1 cm (2⅜ × 2¹³/₁₆ in.)
84.XP.458.34

14 Cabinet (one of a pair), ca. 1745–50
BERNARD II VAN RISENBURGH
French, after 1696–ca. 1766
Oak veneered with bois satiné, kingwood,
and cherry; gilt bronze mounts
149 × 101 × 48.3 cm
(4 ft. 10⅝ in. × 3 ft. ³/₃₄ in. × 1ft. 7 in.)
84.DA.24.2

15 *Mira Calligraphiae Monumenta*
Vienna, written 1561–62; illuminated
ca. 1591–96
Parchment, 150 leaves
16.7 × 12.4 cm (6⁹/₁₆ × 4⅞ in.)
Illustration: *Carnation, Walnut,
Marine Mollusk, and Insects* (fol. 74)
by Joris Hoefnagel, 1542–1601
Ms. 20; 86.MV.527

16 *The Choir and North Ambulatory of the
Church of Saint Bavo, Haarlem*, 1634
PIETER JANSZ. SAENREDAM
Dutch, 1597–1665
Red chalk, graphite, pen and brown ink,
and watercolor, outlines indented for
transfer
37.7 × 39.3 cm (14¹³/₁₆ × 15⁷/₁₆ in.)
88.GC.131

17 *Kelmscott Manor: In the Attics (No. 1)*,
1896
FREDERICK H. EVANS
British, 1853–1943
Platinum print
15.6 × 20.2 cm (6⅛ × 7¹⁵/₁₆ in.)
84.XM.444.89

18 *Ellen Terry at Age Sixteen*, negative 1864;
print, ca. 1875
JULIA MARGARET CAMERON
British, 1815–1879
Carbon print
Diam.: 24.1 cm (9½ in.)
86.XM.636.1

19 *The Entombment*, ca. 1612
PETER PAUL RUBENS
Flemish, 1577–1640
Oil on canvas
131 × 130.2 cm (51⅝ × 51¼ in.)
93.PA.9

20 *A Walk at Dusk*, ca. 1830–35
CASPAR DAVID FRIEDRICH
German, 1774–1840
33.3 × 43.7 cm (13⅛ × 17³/₁₆ in.)
93.PA.14

21 *Oak Tree in Winter*, ca. 1842–43
WILLIAM HENRY FOX TALBOT
British, 1800–1877
Salted paper print from paper negative
19.4 × 16.6 cm (7⅝ × 6⁹/₁₆ in.)
84.XM.893.1

22 Sacramentary
German (Mainz or Fulda), ca. 1025–50
Binding cover
Silver and copper gilt
83.MF.77

23 *Virgin and Child with Saint Anne
and the Infant Saint John*, 1966
FREDERICK SOMMER
American (b. Italy) 1905–1999
Gelatin silver print
24 × 17.6 cm (9⁷/₁₆ × 6¹⁵/₁₆ in.)
94.XM.37.39
© Frederick and Frances Sommer
Foundation

24 *Portrait of Pope Clement VIII
(Ippolito Aldobrandini)*
Italian, 1600–01
Designed by JACOPO LIGOZZI
(Italian, ca. 1547–1626)
Executed by ROMOLO DI FRANCESCO
FERRUCCI (*called* del Tadda)
(Italian, active 1555–1521)
Marble, lapis lazuli, mother-of-pearl,
limestone, and calcite (some covering
painted paper or fabric cartouches) on
and surrounded by a silicate black stone
97 × 68 cm (38³/₁₆ × 26¾ in.)
92.SE.67

25 *The Coronation of the Virgin*, ca. 1420
GENTILE DA FABRIANO
Italian, ca. 1370–1427
Tempera and gold leaf on panel
87.5 × 64 cm (34½ × 25½ in.)
77.PB.92

26 *Oval Basin*, ca. 1550
Attributed to BERNARD PALISSY
French, 1510(?)–1590
Lead-glazed earthenware
47.9 × 36.8 cm (18⅞ × 14½ in.)
88.DE.63

27 *Arrangement of Specimens*, ca. 1842
HIPPOLYTE BAYARD
French, 1801–1887
Cyanotype
27.7 × 21.6 cm (10¹⁵⁄₁₆ × 8½ in.)
84.XO.968.5

28 *Architectural Scene*, ca. 1630
WILHELM FISTULATOR
German, active 1602–1669
Scagliola (faux marble)
43.5 × 50 cm (17⅛ × 19¹¹⁄₁₆ in.)
92.SE.69

29 *An Ancient Port*, 1749–50
GIOVANNI BATTISTA PIRANESI
Italian, 1720–1778
Red and black chalk, brush and brown
and reddish wash, squared in black chalk
38.5 × 52.8 cm (15⅛ × 20¹³⁄₁₆ in.)
88.GB.18

30 *A Young Girl Defending Herself
against Eros*, ca. 1880
WILLIAM ADOLPHE BOUGUEREAU
French, 1825–1905
Oil on canvas
79.5 × 55 cm (31¼ × 21⅝ in.)
70.PA.3

31 *Carved relief*, 1789
AUBERT-HENRI-JOSEPH PARENT
French, 1753–1835
Limewood
69.4 × 47.9 × 6.2 cm
(2 ft. 3⅜ × 1 ft. 6⅞ × 2⅜ in.)
84.SD.76

32 *Christ Child*, ca. 1700
UNKNOWN ARTIST
Italian
Polychromed wood with glass eyes
H: 73.7 cm (29 in.)
96.SD.18

33 *Head of Christ*, ca. 1525–30
CORREGIO (ANTONIO ALLEGRI)
Italian, ca. 1489–1534
Oil on panel
28.6 × 23 cm (11¼ × 9¹⁄₁₆ in.)
94.PB.74

34 *Portrait of the Sisters Zénaïde
and Charlotte Bonaparte*, 1821
JACQUES-LOUIS DAVID
French, 1748–1825
Oil on canvas
129.5 × 100 cm (51 × 39⅜ in.)
86.PA.740

35 *Day-Bed*, 1832–35
FILIPPO PELAGIO PALAGI
Italian, 1775–1860
Maple inlaid with mahogany
with modern silk upholstery
80 × 223.8 × 68.9 cm
(31½ × 88⅛ × 27⅛ in.)
86.DA.511

36 *Portrait of Camillo Rospigliosi*,
ca. 1630–40
Attributed to
GIOVANNI BATTISTA CALANDRA
Italian, 1586–1644
Mosaic in gilt-wood frame
62 × 48.5 cm (24⅜ × 19¹⁄₁₆ in.)
87.SE.132

37 *Louise-Antoinette Feuardent*, 1841
JEAN-FRANÇOIS MILLET
French, 1814–1875
Oil on canvas
73.3 × 60.6 cm (28⅞ × 23⅞ in.)
95.PA.67

39 ROCOCO PANELED ROOM (1730–55)
Photo: Richard Ross

40 *A Boy Holding a Pear (Giacomo
Piazzetta?)*, ca. 1737
GIOVANNI BATTISTA PIAZZETTA
Italian, 1682–1754
Black and white chalk on blue-gray paper
(two joined sheets)
39.2 × 30.9 cm (15⁷⁄₁₆ × 12³⁄₁₆ in.)
86.GB.6777

41 GALLERY OF EUROPEAN SCULPTURE
FROM 1750 TO 1850

41a *Minerva*, 1775
JOSEPH NOLLEKENS
British, 1737–1823
Marble
H: 144 cm (56¹¹⁄₁₆ in.)
87.SA.107
Photo: Richard Ross

41b *Bust of Emperor Caracalla*, 1750–1770
BARTOLOMEO CAVACEPPI
Italian, 1716/17–1799
Marble H: 71 cm (28 in.) including socle
94.SA.46

42 *Saint Ginés de la Jara*, 169(2?)
LUISA ROLDÁN (called La Roldana)
Spanish, 1650–1705
Gilt and polychromed wood
(pine and cedar); glass eyes
H: 175.9 cm (69¼ in.)
85.SD.161
[detail of right arm]